JESUS CHRIST

SON OF MAN

THE EARLY YEARS

To my dad for teaching me to love the Savior.

—LIZ LEMON SWINDLE

*To my mother for teaching me that
the words of Jesus are found in good books.*

—SUSAN EASTON BLACK

JESUS CHRIST

SON

OF

MAN

THE EARLY YEARS

by Susan Easton Black

Artwork by Liz Lemon Swindle

The Greenwich Workshop Press
Seymour, Connecticut

A GREENWICH WORKSHOP PRESS BOOK

Copyright © 2001 by The Greenwich Workshop Press

All art ©Liz Lemon Swindle

Published by The Greenwich Workshop, Inc., 151 Main St., P.O. Box 231, Seymour, CT 06483; (203) 881-3336 or (800) 243-4246.

Library of Congress Cataloging-in-Publication Data

Black, Susan Easton

Jesus Christ : son of man the early years / by Susan Easton Black ; artwork by Liz Lemon Swindle.

p. cm.

Includes bibliographical references.

ISBN 0-86713-067-9 (alk. paper)

1. Jesus Christ—Biography—Early life. 2. Jesus Christ—Mormon interpretations. I. Title.

BT301 .B53 2001

232.9′2—dc21

2001049314

The author and publisher have made every effort to secure proper copyright information. In the event of inadvertent error, the publisher will be happy to make corrections in subsequent printings.

Jacket front: *She Shall Bring Forth a Son*

Book design by Scott Eggers

Manufactured in China by Oceanic Graphic Printing

First Printing 2001

ISBN 13: 978-0-86713-067-6

7 8 9 10 08 07 06

FOR FURTHER READING

The Holy Bible containing the Old and New Testaments. Authorized King James Version. Translated out of the original tongues, and with the former translations diligently compared and revised by His Majesty's special command.

J.R. Dummelow, ed., *A Commentary on the Holy Bible* (New York: Macmillan Company, 1964).

Alfred Edersheim, *Jesus the Messiah: An Abridged Edition of the Life and Times of Jesus the Messiah* (Grand Rapids, Michigan: Wm. B. Eerdmans Publishing Company, 1976).

Ralph Gower, *The New Manners and Customs of Bible Times* (Chicago, Illinois: Moody Press, 1987).

National Geographic Society, *Everyday Life in Bible Times* (National Geographic Society, 1967).

Wolfgang E. Pax, *Footsteps of Jesus* (Jerusalem, Israel: Nateev Publishing, 1970).

Hayyim Schauss, *The Jewish Festivals: A Guide to Their History and Observance* (New York: Schocken Books, 1938).

James E. Talmage, *Jesus the Christ* (Salt Lake City, Utah: Deseret Book Co., 1983).

CONTENTS

JESUS

The camera rolls and an actress portraying Mary gently holds a newborn son. She then wraps the newborn in swaddling cloths and lays him in a manger. A doctor stands near the scene to give timely aid to the infant, if necessary, and a concerned young mother, just released from the hospital, anxiously looks on. In the corner, a writer makes note of the tender moment—a moment captured with hundreds of camera flashes. ¶ The actress rises to her feet and with tearful reluctance gives the newborn back to his mother. The doctor checks the infant and assures everyone, "The baby is fine."

The scene quickly ends and for some it will soon be only a fleeting memory. But for the artist and the writer, it is just one of many historic reenactments of the early life of Jesus Christ that will be captured on film. ¶ By studying the photographic prints of these reenactments from the village of Bethlehem, the steep hillsides of Nazareth, and the shores of Galilee, the artist creates lifelike portraits that convey an unusually authentic representation of the mortal life of Jesus. From the world of scholarship, the writer creates a complementary text that reveals beginning glimpses of the greatest story ever told. ¶ In that process, both the artist and the writer have discovered anew the truth of the words of Isaiah, "Behold, a virgin shall be with child, and shall bring forth a son." And they acknowledge that the babe, born of a virgin on the outskirts of Bethlehem, was the "Wonderful, Counsellor, The Mighty God, The Everlasting Father, The Prince of Peace."

SHE SHALL
BRING
FORTH A
SON

Behold, a virgin shall be with child, and shall bring forth a son," prophesied Isaiah. Yet since his prophecy, hundreds of years had passed without its fulfillment. Only a few young maidens still dreamed of becoming the promised virgin, and yet fewer old men dared imagine the birth of the chosen son. The despair stemmed from centuries of foreign servitude, as it had been nearly one thousand years since one of their own, King David, had ruled over Judaea. Since then, Babylon, Egypt, Greece, and Rome had subjected the Jewish population to the atrocities of war and bondage. ¶ As our story begins, Rome ruled Judaea with an iron hand. However, the Roman emperor, Caesar Augustus, acknowledged by his people as a god, was no more than a pagan

overlord to the Judaeans. In sacred lands where holy prophets had once walked, replicas of Caesar's image were detested, but there was little fight left in the once-proud people. Hopes of overthrowing Caesar or his vassal king, Herod, were only whispered. "Let my people go" was an unspoken cry, reminiscent of the words of Moses before the Egyptian pharaoh. Yet, after centuries of servitude, the cry went unanswered. Could it be that Jehovah, God of the Judaeans, had abandoned his once-favored people? No one dared speak the question aloud. Rome ruled the world with an inflexible power that few could defy.

This was the setting when Isaiah's prophecy became a reality. We know not how it was done any more than we comprehend creation or how the heavens began. Yet we know that this child, born of a virgin on the outskirts of Bethlehem, was the prophesied "Wonderful, Counsellor, The Mighty God, The Everlasting Father, The Prince of Peace." Although the child would be "despised and rejected of men" and would grow to be "a man of sorrows, and acquainted with grief," he was the child born of a virgin who would triumph over all enemies and conquer even death.

The story of this chosen child has been passed from generation to generation. It is a story of fearful yesteryears when Herod and Caesar ruled with

unrelenting tyranny, and then of an unlikely crib, a manger, in which a small infant was lovingly placed by his mother. It is the greatest story ever told. It is the story of Jesus the Christ—the Son of Man.

Our telling of the story starts in the small community of Nazareth located in the foothills of lower Galilee. In this sequestered village, a young woman with a common name, Mary, had a heavenly experience that changed her life and the destiny of the world forever. Perhaps before the experience, Mary had imagined her destiny only in terms of her betrothal to Joseph the carpenter, their forthcoming wedding, and the festivities surrounding those events.

If the carpenter and Mary followed Jewish customs of the time, they would have entered into a raised tent or booth to be bound in an espousal ceremony. In front of solemn witnesses, who gathered to mark the occasion, Joseph would hand Mary a coin or its equivalency, and pronounce so that all could hear, "Lo, thou art betrothed unto me." When the formalities ended, villagers would have rejoiced with the young maiden, for she was promised to Joseph, and within a year, wedding festivities would celebrate their union.

It was after Mary had been espoused to Joseph that an angel named Gabriel was "sent from God" to bring her glad tidings of great joy. "Hail, thou that art

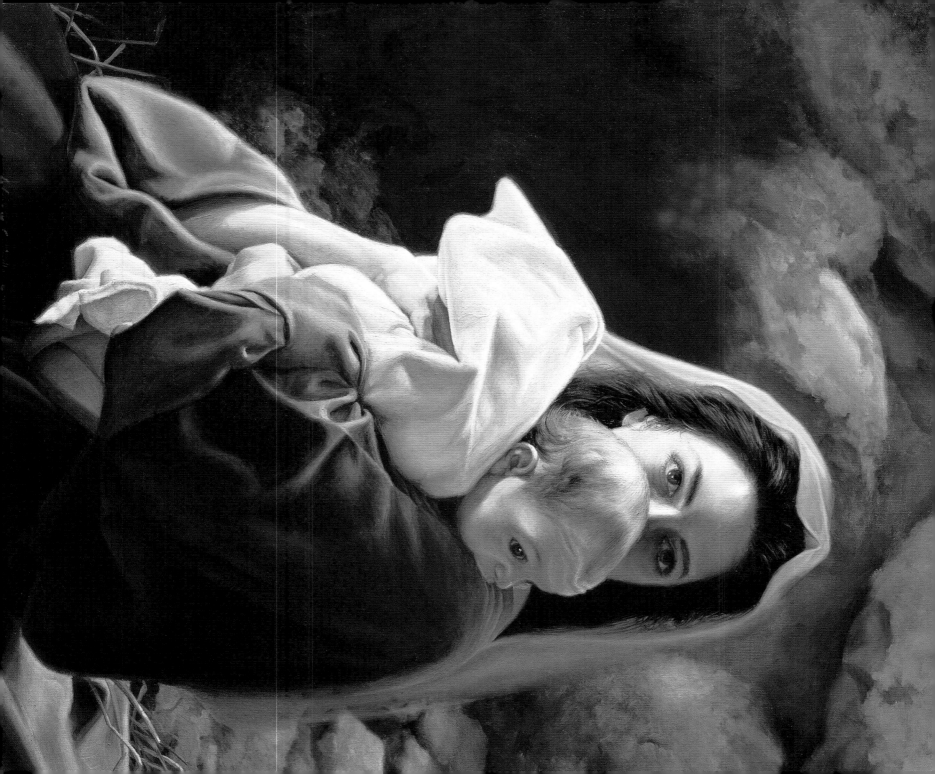

highly favoured, the Lord is with thee: blessed art thou among women" was the angelic salutation. The greeting, although glorious, was troubling to Mary. "Fear not, Mary: for thou hast found favour with God," the angel stated. "And, behold, thou shalt conceive in thy womb, and bring forth a son, and shalt call his name JESUS. He shall be great, and shall be called the Son of the Highest: and the Lord God shall give unto him the throne of his father David: And he shall reign over the house of Jacob for ever; and of his kingdom there shall be no end."

Mary may have believed the mission of the prophesied child, but she was concerned about her ability to bear a son. "How shall this be, seeing I know not a man?" she asked. How could a virgin conceive? The angel explained, "The Holy Ghost shall come upon thee, and the power of the Highest shall overshadow thee."

As Mary thought on this explanation, Gabriel assured her "with God nothing shall be impossible." As a manifestation of the omnipotent power of God, Gabriel spoke of a woman beyond her childbearing years. "Thy cousin Elisabeth, she hath also conceived a son in her old age: and this is the sixth month with her, who was called barren." Then Mary exclaimed, "Behold the handmaid of the Lord; be it unto me according to thy word."

And it was so. The child conceived in Mary's womb was the Son of God—the Son that would be "a light to lighten the Gentiles, and the glory of [Jehovah's] people Israel." Yet, for this chosen mother, the years following his birth would not be easy. They would be fraught with mockery, thorns, and a cross. On this night, however, when the angel spoke of Mary as the chosen vessel of the Lord, she was not troubled by thoughts of harm to her child. She was confident and joyous.

With whom could she share her joy as the angelic visitation ended? With the elderly priest Zacharias, who six months before had also received a visit from the angel Gabriel? No! The angelic message, "Fear not, Zacharias: for thy prayer is heard; and thy wife Elisabeth shall bear thee a son," had left Zacharias in speechless silence. His wife Elisabeth, however, carried the child of promise in her womb, and she could converse with Mary about the greatness of God. Thus, after the angel departed, Mary arose and left Nazareth to journey "into a city of Juda" to find Elisabeth.

Although Mary left the village of Nazareth in haste, she did not journey alone. Jewish tradition mandated that betrothed women be accompanied. The tradition required her to have an escort on the crowded

road from Nazareth to Juda. When Mary and her companions arrived in Juda, Mary went directly to the "house of Zacharias, and saluted Elisabeth."

As she entered the home, Elisabeth exclaimed to Mary, "Blessed art thou among women, and blessed is the fruit of thy womb." The child Elisabeth carried in her womb also acknowledged the entrance of the mother of the Son of God. The unborn child leaped, and as he did, Elisabeth was "filled with the Holy Ghost." The account of the expectant mother of John the Baptist extending a greeting to the expectant mother of the Messiah is a singular event in holy writ. Yet, Elisabeth wondered aloud, "[Why] the mother of my Lord should come to me?" Mary explained her visit by expressing her blessed state: "My soul doth magnify the Lord, And my spirit hath rejoiced in God my Saviour... from henceforth all generations shall call me blessed. For he that is mighty hath done to me great things; and holy is his name."

Mary also spoke of the power of God in ages past. "[The Lord] hath scattered the proud in the imagination of their hearts. He hath put down the mighty from their seats, and exalted them of low degree. He hath filled the hungry with good things; and the rich he hath sent empty away." Citing all the wonders and greatness of Jehovah, Mary ends her remembrance

by humbly acknowledging that the most miraculous is that he has been mindful of her. In these words Mary reveals her exquisite joy in being chosen to bear the Son of God. In her rejoicing there is no hint of reservation, selfish concern, fear, or pride—only confidence that "with God nothing is impossible."

Unfortunately, such joyous expressions faded quickly. Three months later, as Mary returned to Nazareth, the welcome was not like the joy she had known with Elisabeth. Her return to Nazareth proved unsettling to Joseph the carpenter. He perceived that she was with child and had breached her betrothal vow. Such presumed licentious behavior demanded an immediate end of their betrothal and called for the requisite punishment prescribed by Jewish law.

The decision facing Joseph was twofold. Would he choose the one of public notice—a trial in the synagogue before three judges? Or would the carpenter choose the private notice—a written document certifying the espousal had ended? As Joseph considered the matter, he was of the opinion to "put [Mary] away privily." This was not to be. An "angel of the Lord appeared unto him in a dream, saying, Joseph, thou son of David, fear not to take unto thee Mary thy wife: for that which is conceived in her is of the Holy Ghost. [Mary] shall bring forth a son, and thou shalt call his name

JESUS: for he shall save his people from their sins."

This message reminded Joseph of Isaiah's words: "Behold, a virgin shall be with child, and shall bring forth a son, and they shall call his name Emmanuel, which being interpreted is, God with us." His relief in knowing the parentage of the unborn child is not recorded in the Gospels. We can only imagine that any misgivings Joseph may have nurtured gave way to unspeakable joy as he learned that his beloved virgin would be the mother of the Son of God. With that knowledge, he surely had the overwhelming realization, that he, Joseph the carpenter, would be the provider and protector of both mother and child. It was he who would share in the sacred responsibility of rearing the son of heavenly heritage with love and righteousness.

Although his thoughts are not recorded, Joseph, like Mary three months earlier, arose and "did as the angel of the Lord had bidden him, and took unto him his wife." We assume that Joseph did not delay the wedding festivities. Which day Joseph and Mary wed is not mentioned in the Gospels, although tradition favors the third day of the week. Basis for the tradition stems from the creation story in the Book of Genesis, in which the word "good" appears twice in the description of God's creations on the third day. Because of this repetition, it was thought that marriages celebrated on the third day of the week would receive a double blessing from Jehovah.

On his wedding day the groom, with a myrtle garland atop his head as a symbol of love, would search the village for his bride. Friends, carrying lighted torches followed the groom in hopes of helping him find his bride. Typically, the groom's search ended in the bride's parental home where the groom announced, "Come see the treasure I have found," as he lifted the veil from his bride's face and laid it on his shoulder. His words and actions led villagers to exclaim, "The government shall be upon his shoulder," meaning he had the right to begin a family. The groom then led his bride in a festive procession towards their new home. During the procession some friends played music, others danced, and kindred waved flowers and myrtle branches. When the procession reached the new home, the guests would say, "Take her according to the Law of Moses and of Israel." The festive couple were then crowned with garlands, encircled by guests under a wedding canopy, and called king and queen respectively. The marriage feast—a celebration that often lasted for a week or two—began after all in attendance were assured that the groom promised to honor and care for his bride after the manner of an Israelite.

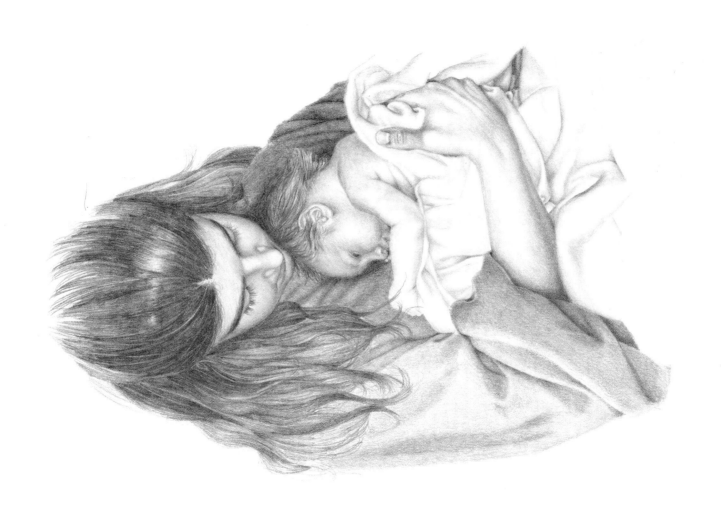

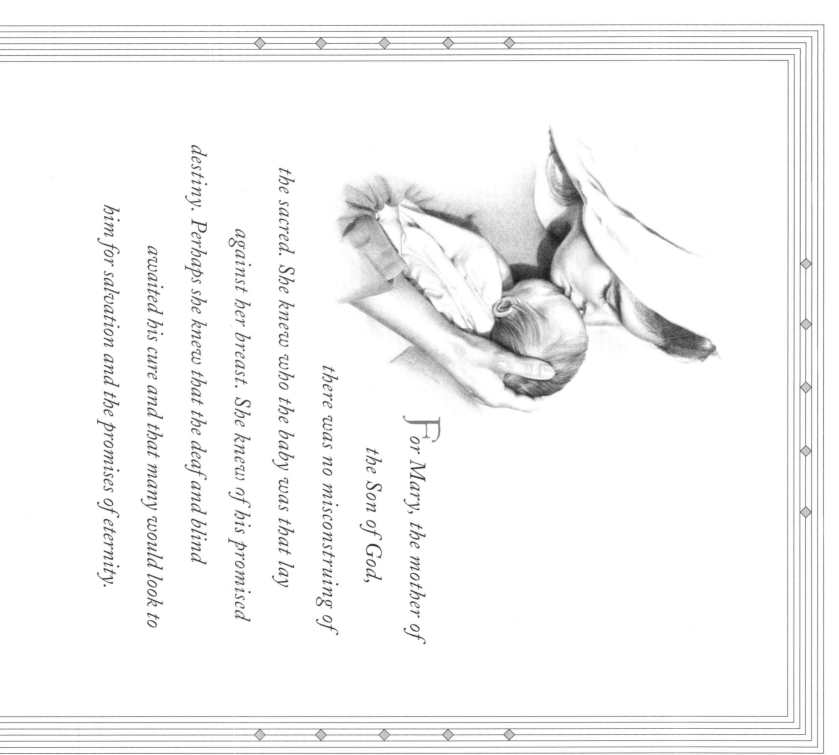

For Mary, the mother of the Son of God, there was no misconstruing of the sacred. She knew who the baby was that lay against her breast. She knew of his promised destiny. Perhaps she knew that the deaf and blind awaited his cure and that many would look to him for salvation and the promises of eternity.

The Gospel writer Luke did not describe the marriage festivities of Mary and Joseph, but he was not silent about the ever-present power of Rome. A "decree from Caesar Augustus, that all the world should be taxed" was on his mind and perhaps also on the minds of those who participated in the wedding festivities. A decree from Caesar, ruler over an empire that stretched from England on the west, along the Mediterranean coastline on the east, and to Africa on the south, was not to be ignored. His royal whims, no matter how repugnant to his subjects, were not to be denied.

Although the Jews abhorred the Roman taxation, they complied with the tax by first journeying to ancient family lands to register. Among those traveling from Judaea, towards the land where the famed King David once roamed the hills and dwelt among his kin, were Joseph the carpenter and his wife Mary "being great with child." Their journey took them nearly ninety miles from Nazareth to the outskirts of Bethlehem of Judaea.

Joseph sought shelter in this Judaean community, situated about five miles south of the Holy City of Jerusalem. Scholars speculate that he sought lodging in an inn or caravansary (called a *khan*) built to accommodate travelers who traversed the route between Jerusalem and Egypt. This particular type of inn was a large, walled enclosure made of stone or sun-dried brick. According to tradition, the inn's rooms and stalls surrounded a central courtyard.

If travelers reached the inn early in the day, they were usually welcomed by the innkeeper. If they arrived in the evening, the door was closed for protection and travelers were encouraged to move along. Arriving in the evening and unwelcome by the innkeeper, Joseph searched for lodging in the terraced limestone hillsides that bordered Bethlehem. In a cave within a hillside "the days were accomplished that [Mary] should be delivered. And she brought forth her firstborn son." Like generations of Jewish mothers before her, Mary wrapped her newborn in swaddling clothes to restrain his movements. Unlike most Jewish mothers, she had no crib for her baby. Improvising, Mary "laid him in a manger."

We turn from the manger that cradled the holy babe to those who would become witnesses that the Son of God, the promised Messiah, had been born. For centuries, Jewish tradition held that the Messiah would be revealed from Migdal Eder, which was a tower near Bethlehem on the road between Jerusalem and the city of David. From this tower, shepherds guarded their sheep that were destined to be temple sacrificial offerings. On the holy night of the birth of

the Son of God, the glory of the Lord shone round about these shepherds, and, "they were sore afraid." They knew about caring for sheep and about the significance of the sacrificial firstborn lamb, but not of God's glory. "Fear not: for, behold, I bring you good tidings of great joy, which shall be to all people," announced an angel sent from the presence of God. "For unto you is born this day in the city of David, a Saviour, which is Christ the Lord." The announced child was not just another baby born of a woman in Judaea. This baby was the Son of God—the Holy One, the Great I AM, the Son of Man. He was Jesus the Christ, the Savior of the World.

The angelic declaration resonated with the ancient Bedouin custom of a birth announcement: "We bring you good news of a great joy, for to you is born this day..."but there the similarity stops. As the shepherds listened to the angelic message, "suddenly there was with the angel a multitude of the heavenly host praising God, and saying, Glory to God in the highest, and on earth peace, good will toward men." The announced glad tidings were the gospel message of peace, the fulfillment of the Messianic hope—the hope that would be found in "the babe wrapped in swaddling clothes, lying in a manger" nearby.

"Let us now go even unto Bethlehem, and see

this thing which is come to pass, which the Lord hath made known unto us," the shepherds said one to another. How many caves they searched in hopes of finding a manger that cradled the Messiah is not known. What is known is that when they found "Mary, and Joseph, and the babe lying in a manger" they rejoiced for they had seen "[what] the Lord hath made known" unto them.

On that night of nights, Joseph and Mary witnessed the shepherds adoring the newborn king. As the shepherds retreated from the holy family, "they made known abroad the saying which was told them concerning this child." Those who listened "wondered at those things which were told them by the shepherds." They mused, "Could it be that the prophecies of old were beginning to be fulfilled?" Some wondered and others speculated, but for Mary, the mother of the Son of God, there was no imagining or misconstruing of the sacred. She knew who the baby was that lay against her breast. She knew of his promised destiny. Perhaps she knew that the deaf, lame, and blind awaited his cure and that many would look to him for salvation and the promises of eternity. Yet, she did not boast in her knowledge that night or in the days that followed. Instead, she reverently "kept all these things, and pondered them in her heart."

On that night of nights, Mary knew the angelic promise,
"Thou shalt bring forth a son," was fulfilled as she tenderly
held her newborn infant. In that moment, she could resonate
with the heavenly host who praised God
for the babe's birth by saying, "Glory to God
in the highest, and on earth peace,
good will toward men."

CHILD
OF
GRACE

esus was circumcised eight days after his birth. "Blessed be the Lord our God, who hath sanctified us by his precepts and hath given us the law of circumcision" were the prescribed words pronounced during the circumcision ritual. The father of the newborn added the words "Who hath sanctified us by his precepts and hath commanded us to enter the child into the covenant of Abraham our father." ¶ After the formal words were spoken and the infant son was circumcised, the child's name would be announced. Traditionally, the name pronounced upon a firstborn son was that of the paternal grandfather, but in this instance an ancestor's name would not suffice. His divinely chosen name, Jesus, meaning Savior-Deliverer, was given. According to Jewish ritual, it was believed that Jesus entered the covenant of Abraham once he received his name. ¶ Forty days

following the birth, his mother would fulfill another Jewish ritual. In the custom of young Judaean mothers for centuries, Mary presented herself and her sacrificial offering at the temple courts in Jerusalem. There, in a designated courtyard, a priest accepted her offering of two turtledoves and pronounced the prescribed words assuring her of restored purity following the birth. Did the priest recognize Mary as the prophesied virgin and the child she caressed as the Son of God? Did he think the son in her arms was simply another Judaean? Simeon, a devout and just man, knew "by the Holy Ghost, that he should not see death, before he had seen the Lord's Christ," and he recognized the infant as the Redeemer of the World and the mother as the chosen virgin. Simeon took the newborn into his arms and praised God, saying, "Lord, now lettest thou thy servant depart in peace... For mine eyes have seen thy salvation." He then spoke eloquently about the Messianic mission of the child, yet tempered his eloquence with hints of a difficult path that lay ahead. Amid his visionary expression of the infant's future, he turned to Mary and said, "A sword shall pierce through thy own soul." Perhaps Simeon knew something of the sorrow and agony that awaited Mary, as she would later watch her son hang from the cross at Calvary.

There was no time for explanation that day on the Temple Mount, for just as Simeon was speaking, Anna, an elderly prophetess who had "served God with fastings and prayers night and day," came forward and also recognized the babe as the Messiah. She also "gave thanks likewise unto the Lord" for the infant. These two servants of God did not need others to identify mother or child nor did they need a priest to remind them of the Lord's promises to his favored people. They recognized the Hope of Israel and knew this birth was the beginning of the fulfillment of ancient prophesies.

Mary and Joseph left Simeon, Anna, and the Temple Mount that day and returned to Bethlehem. They made their home in this quiet, rural setting. To many it must have appeared that they would remain residents of Bethlehem, but travelers from the east would quickly change their opinion. Wise men from lands east of Judaea—perhaps the Arabian Desert, Chaldaea, or even farther—arrived in Jerusalem searching for a child born to be king. Christian legend numbers the wise men from three to twelve and depicts them as kings or magi who followed the direction of a star in search of the rightful heir of Judah.

This portrayal of the wise men is speculative. What is true is that when the wise men entered Jerusalem, they sought an audience with the reigning

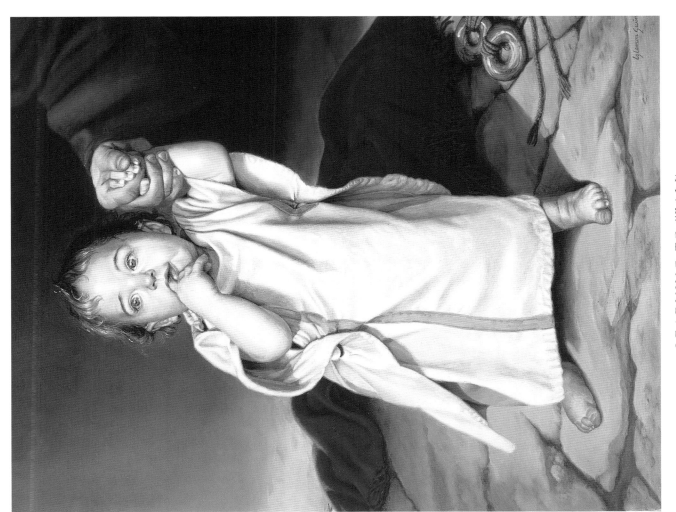

LEARNING TO WALK

◆ 25. ◆

"Where is he that is born King of the Jews?
For we have seen his star in the east,
and are come to worship him," the wise men
asked of Herod. With veiled malice in his heart,
the king replied, "Go and
search diligently for the
young child; and when ye
have found him, bring me
word again, that I may come
and worship him also."

Roman ruler. "Where is he that is born King of the Jews? For we have seen his star in the east, and are come to worship him," they asked of Herod. Their question implied that Herod knew of the prophesied star that would appear upon the birth of Judah's rightful king. Herod did not know the answer, and the question caught him unawares. He had been so preoccupied with ferreting out threats to the throne within his own domicile that he had ignored signs in the heavens and the ancient prophesies.

Herod was "troubled, and all Jerusalem with him" at the wise men's question for it played upon his greatest fear—a "rightful" successor to his throne. There was, of course, the additional element of greed. The wise men arrived in Jerusalem laden with gifts for the newborn king, but offered no gifts to Herod. Their costly treasures were not meant for the puppet king, but for the child whose greatness and power would surpass any reputation achieved by Herod. They were meant for the child destined to be King of Kings. The visitors' blatant disregard for the custom of presenting elaborate gifts to the ruling monarch was unacceptable to Herod.

For Herod, whose delicate diplomacy had won the praise of Rome and whose might had stopped revolutionaries in Judaea, the wise men's failure to give him gifts and their question about a rightful king posed an enormous threat. He "gathered all the chief priests and scribes of the people together, [and] demanded of them where Christ should be born." The learned men answered, "Bethlehem of Judaea: for thus it is written by the prophet."

With thinly veiled deception, Herod suggested to the wise men, "Go and search diligently for the young child [in Bethlehem]; and when ye have found him, bring me word again, that I may come and worship him also." The wise men did not need to search, for "the star, which they saw in the east" went before them and led them to the carpenter's home in Bethlehem. There in the humble abode they found the prophesied king.

Upon seeing the child Jesus, the wise men "fell down, and worshipped him." They opened the treasures they had brought and gave their precious gifts to the child. The costly gifts, a dramatic contrast from the simple surroundings in the carpenter's home, were not typical newborn presents. They were not a toddler's toys; they were gifts for a ruling monarch, gifts for a king.

The gifts presented to Jesus were symbols of his royal destiny. The wise men brought gold to celebrate the King of Kings. (Later, in Christian medieval tradition, gold became the customary gift to acknowledge royalty.) Frankincense, incense used in ritual sacrifice

at the Temple Mount, symbolized Jesus' priestly role as the Great High Priest. The gift of myrrh, a pain-killer and an embalming ingredient, foreshadowed his atonement and death.

After the gifts were presented to the rightful heir of Judah's throne, the wise men made preparations to return to the east by way of Jerusalem and King Herod's palace. When they were "warned of God in a dream" of Herod's plan to destroy the chosen child, they did not return as planned to give Herod directions to the child's home in Bethlehem. When the wise men failed to return to Jerusalem, Herod perceived it as an affront to his legitimacy. He didn't send soldiers to force the wise men back to Jerusalem. In a fit of uncontrolled anger, the king sought revenge. He unleashed his wrath on the small community of Bethlehem—a community that was home to the holy family and also home to Zacharias, Elisabeth, and their son, John.

Herod knew that it was not the wise men that threatened his kingdom, but a child living in Bethlehem—a child with a royal destiny. Herod ordered his soldiers to slay "all the children that were in Bethlehem, and in all the coasts thereof, from two years old and under." The commotion in the town as soldiers unsheathed their blades to carry out his hellish edict is painful to imagine. Mothers

pleaded for the innocent, and fathers, like Zacharias, died rather than disclose the hiding places of their sons. There were heroes and heroines in Bethlehem who protested this heinous crime of Herod.

One by one, the innocent were slain. Those who could barely walk or question why, lost their lives due to the unchecked jealousy of Herod, whose every jot and order were executed to the fullest. Sorrowful fathers and mothers saw their offspring cut down by the sword for no reason other than their age. The object of the execution, the child destined to be king, was not found in Bethlehem that day.

"Behold, the angel of the Lord appeareth to Joseph in a dream, saying, Arise, and take the young child and his mother, and flee into Egypt, and be thou there until I bring thee word: for Herod will seek the young child to destroy him." Without questioning and in obedience to the angelic command, and with the cover of night to cloak their escape, Joseph took Mary and the child Jesus away from Bethlehem. The holy family crossed the wastelands of the Negev and Sinai deserts seeking a respite in Egypt from the ungodly tyrant Herod. They found safety in the land of pyramids and past greatness.

It is believed that Joseph, Mary, and the child Jesus blended into the Egyptian society better than

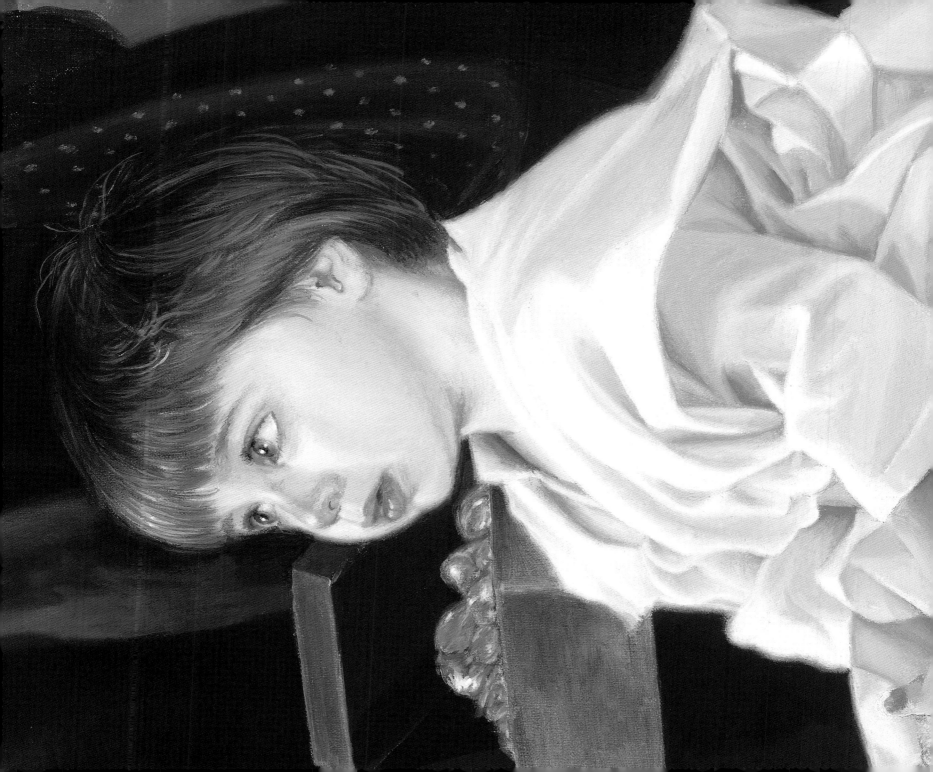

"The angel of the Lord appeareth to Joseph in a dream, saying, Arise, and take the young child and his mother, and flee into Egypt, and be thou there until I bring thee word: for Herod will seek the young child to destroy him.

When he arose, he took the young child and his mother by night, and departed into Egypt."

might be imagined. Although it had been over a millennium since Joseph of Egypt and Moses had walked that desert land, Egypt was still home to multitudes of the children of Israel. A surprising number of Jewish communities dotted banks along the Nile River and the Mediterranean coastline. Many Jewish refugees had crowded into the famed Egyptian city of Alexandria, dubbed "Little Jerusalem" at that time. Christian tradition places the holy family's home near the Nile River, where they awaited word from Jehovah that it was safe to return to Bethlehem. That word did not come until after the death of Herod.

Herod's physical strength waned during the holy family's brief sojourn in Egypt. Not long after the tragedy in Bethlehem, death stalked the despot. Realizing that his demise was imminent and wishing none of his three sons to surpass his own greatness, Herod divided his domain between them. Archelaus was appointed king over the choice lands of Judaea, Samaria, and Jerusalem. Antipas and Philippus, the two other brothers, received less favorable lands.

When Herod died, Archelaus (perhaps because he was the favored son) orchestrated an extravagant funeral procession, the likes of which had not been seen in Judaea. The body of Herod was wrapped in precious purple robes and carried on a golden bier studded with rare stones. Following the golden bier, paid pipers and professional mourners joined a large military cortege and five hundred servants in a mournful procession to the burial site. The garish splendor was a marvel and almost a wonder to observant Jews in the land of Judaea, but it was marred in the eyes of Archelaus by Jewish subjects who could not contain their merriment at the death of Herod. As Judaeans celebrated the tyrant's demise, their festivities on byways and the outskirts of Judaea nearly overshadowed the expensive funeral cortege.

Missing from the festivities were Joseph, Mary, and the child Jesus. Surely they had heard rumors of Herod's death, but the rumors did not compel them to leave Egypt. They remained on foreign soil awaiting word from God. Once again it was an angel, appearing to Joseph in a dream, that provided the needed instructions: "Arise, and take the young child and his mother, [out of Egypt] and go into the land of Israel: for they are dead which sought the young child's life." This was the word the holy family needed in order to make preparations for their return to Judaea.

Joseph took Mary and the child Jesus across the Negev and Sinai deserts toward their homeland. When they arrived at the Judaean border, Joseph learned how Herod's domain had been divided

between his three errant sons. When he heard that Archelaus reigned "in Judaea in the room of his father, Herod," Joseph decided not to return to Bethlehem. Joseph knew that Archelaus was an unrestrained tyrant with the same evil temperament as his father. Concerned for the safety of the Son of God, Joseph "turned aside into the parts of Galilee," to a community he knew well—Nazareth.

The holy family made their home in the agrarian society of Nazareth, where the angel had first brought salutations to Mary. It does not appear that neighbors or even kindred knew that Jesus was the Son of God. Family and old friends would welcome them back and greet Jesus as the carpenter's son. Perhaps it was safer for the growing child to be recognized as Joseph's son rather than the son with a future Messianic mission. Surely it was safer for the child to mature as Jesus of Nazareth rather than Jesus, a target of the Bethlehem tragedy.

In the rural community of Nazareth, Jesus "grew, and waxed strong in spirit," and was filled with wisdom. As he "increased in wisdom and stature," gospel writers tell us that he also increased "in favour with God and man," for the "grace of God was upon him." Other than this New Testament passage, details of Jesus' childhood are not known for the stretch between his boyhood days in the hills of Nazareth to his baptism in the River Jordan.

The ancient prophet Isaiah, however, does speak of those days: "He shall grow up before him as a tender plant, and as a root out of a dry ground: he hath no form nor comeliness; and when we shall see him, there is no beauty that we should desire him." Although his prophetic words are difficult to interpret, it is reasonable to suppose that Isaiah knew that Jesus would look like other boys of comparable age in Galilee. Apocryphal accounts reveal interesting, even fanciful stories of Jesus' boyhood days in Nazareth. One story depicts the young Jesus carrying spilled liquid in his cloak, but never losing a drop of moisture. Another tale has him lengthening a board in the carpenter's shop by merely pulling on it lengthwise. In still another story, the boy Jesus claps his hands to bring dead sparrows back to life. These stories are contrasted with a host of vengeful tales suggesting that the child Jesus had an uncontrollable temper. In one account, he silences a local rabbi who is attempting to teach him the ways of God. In another story the boy Jesus turns rude playmates into goats. Finally, in another tale, he strikes annoying neighbors dead. These stories are the result of two thousand years of expanded and embellished storytelling and may not

accurately chronicle the life of young Jesus Christ.

There are assumptions that *can* be made about Jesus' childhood years. First and foremost, Jesus was raised in a Jewish household with Jewish customs. For example, a *mezzuzah* was probably mounted on their doorpost. It held a folded piece of parchment on which was written: "Hear, O Israel: The Lord our God is one Lord: And thou shalt love the Lord thy God with all thine heart, and with all thy soul, and with all thy might." This scriptural verse reminded those who entered or left the Jewish home to hear and listen to the word of God. Touching the *mezzuzah* with a finger and then touching the lips with the same finger was a symbolic remembrance and prayer to God.

Other forms of Jewish worship in the home would be lullabies from the Book of Psalms. Typically, mothers sang lullabies to their little ones while fathers were responsible for teaching scriptural passages, prayers, and other wisdom to their offspring. And then, of course, there were the elaborate rituals surrounding the Sabbath day observance. At sunset on Friday, a priest, standing atop the tallest structure in

Jesus "grew, and waxed strong in spirit," and was filled with wisdom. As he "increased in wisdom and stature," gospel writers tell us that he also increased "in favour with God and man," for the "grace of God was upon him."

the community, blew a ram's horn to announce the approach of the Sabbath. This first blast would signal laborers in the fields near Nazareth to cease their work. Those who worked in town waited until the second blast to close their shops. The third blast announced the time to kindle Sabbath lights. After candles were lit, three successive blasts heralded the sacred Sabbath rest—a day set apart to worship God. On the Sabbath, family members wore fine clothes, worshiped in the synagogue, and, in other significant ways, praised Jehovah.

It can be assumed that the parchment, lullabies, scriptural teachings, and observance of the Sabbath were aspects of the childhood of Jesus. Beyond the typical Jewish customs of his day, no one knows with certainty the details of his life between his return to Nazareth after Herod's death and the next mention of him in the Bible, at age twelve.

Each year, the Feast of the Passover was held in Jerusalem to commemorate the deliverance of the children of Israel from Egyptian bondage. At the time of Jesus, Jews hoped that they would be freed from

foot. They all turned their faces toward Jerusalem, for attendance at Passover was not only a festive celebration, but also requisite for the people of Judah.

Great multitudes of Judaeans, nearly one hundred thousand, made the sacred pilgrimage to Jerusalem in the days of Jesus. Although they seemed a cohesive group as they traveled, once in Jerusalem each pilgrim began an individual errand of worship. For some it was finding shelter and the right sacrificial lamb. For Jesus and other twelve-year-old boys, it was to formally present themselves before a priest at the Temple Mount. The priest, upon determining that each boy had reached the requisite age, ritualistically pronounced the boy a Son of the Law.

Beyond the typical Jewish customs of his day, no one knows with certainty the details of his life between his return to Nazareth after Herod's death and the next mention of him in the Bible, at age twelve.

This distinguished title gave each boy the right to hold a position in his local synagogue, be recognized as an official member of the community, choose a worthy vocation, and enter into advanced educational studies.

These temporal blessings, although significant, paled for most twelve-year-olds when compared to the eternal blessings associated with their new distinction. The eternal blessing in becoming a Son of the Law

Roman bondage, In the way their ancestors had been released from Egyptian slavery. "They spoke of the discomfiture of Pharaoh and the Egyptians, hoping at the same time for the identical plagues to be visited upon the Roman emperor, his governors, and his soldiers." With hopes high, faithful Judaeans turned their thoughts towards their forthcoming journey to Jerusalem. The journey of twelve-year-old Jesus to Jerusalem, like generations of young men before him, was mandatory according to Jewish law. At age twelve, boys were able for the first time to join in the pilgrimage of faithful men and women to Jerusalem to celebrate Passover festivities.

From among those who gathered together in Nazareth to make the pilgrimage, one man would be selected the leader. Traditionally, the leader shouted to the congregated pilgrims, "Arise ye, and let us go up to Zion, to the House of our God." Joyful followers arose at his bidding and sang hymns of praise from the Book of Psalms as they followed the leader up to the Holy City. Prosperous pilgrims drove chariots, the afflicted rode beasts of burden, and the more able journeyed on

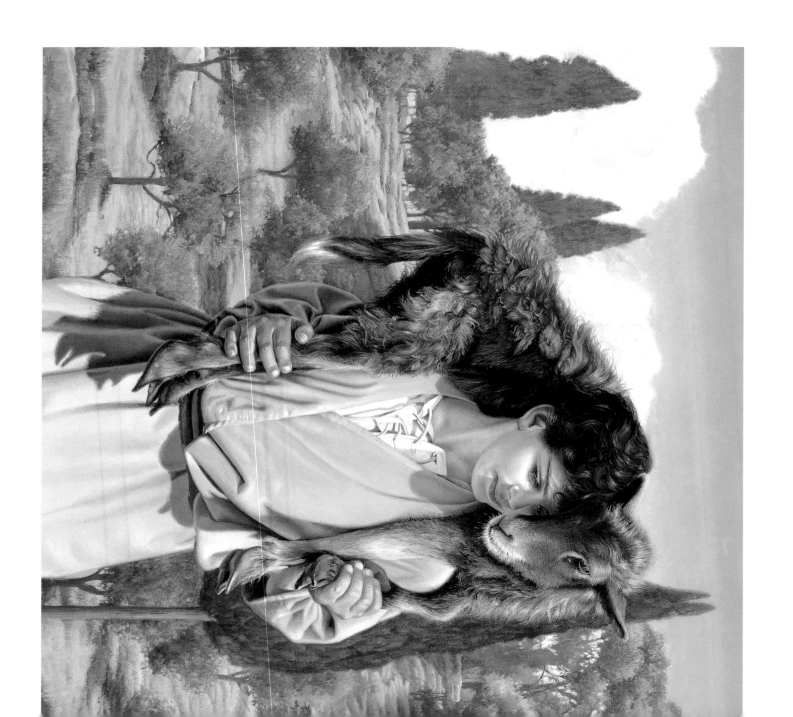

was that the boy would dine with the patriarchs of Israel—Abraham, Isaac, and Jacob at a future Messianic feast. There, at the greatest Passover, the Savior, the Lamb of God, the Hope of Israel, would preside.

After Jesus was declared a Son of the Law and after the other customs associated with Passover were completed, pilgrims from Nazareth and throughout the Judaean world left Jerusalem and returned to their homes rejoicing for having been in the Holy City. Among the pilgrims returning to Nazareth that year were Joseph and Mary. They were unaware that "the child Jesus tarried behind in Jerusalem." Believing him to be in their company, they went a day's journey before discovering his absence.

"And when they found him not, they turned back again to Jerusalem, seeking him." It was not until the third day that they found him at the Temple Mount "sitting in the midst of the doctors, both hearing them, and asking them questions. And all that heard him were astonished at his understanding and answers." This scene of a young Son of the Law talking with learned doctors on the Temple Mount was not unusual. Ancient Jewish records reveal sporadic instances of precocious young men conversing with rabbis, scribes, and doctors. What was unusual was

that the doctors were listening to Jesus and asking *him* questions. Thus, when Joseph and Mary saw him, "they were amazed." Yet, Mary had not forgotten her feelings of unrest over not finding Jesus among the pilgrims returning to Nazareth.

Mary inquired of her son, "Why hast thou thus dealt with us? Behold, thy father and I have sought thee sorrowing." Jesus answered his mother, "How is it that ye sought me? wist ye not that I must be about my Father's business?" His words, the first recorded words of the Son of God in holy writ, reveal his knowledge of his parentage and true identity. Yet, Joseph and Mary "understood not the saying which he spake unto them."

Surely they had not forgotten that Jesus was the Son of God. They could not have forgotten the gifts of the wise men nor their escape into Egypt to protect his life. Yet, it was not time for the ministry of Jesus to begin. Years, as many as eighteen, would pass before his baptism by John the Baptist and his clarion call, "Follow me." There was still time to nurture him in Nazareth as he prepared for his ministry. Yet what could Joseph and Mary teach the Son that had taught the learned doctors at the Temple Mount? In obedience, Jesus left the Mount and the Holy City that day with Joseph and his mother, Mary. He returned to the pastures of Nazareth and his childhood home. It remained for him to complete a season of preparation.

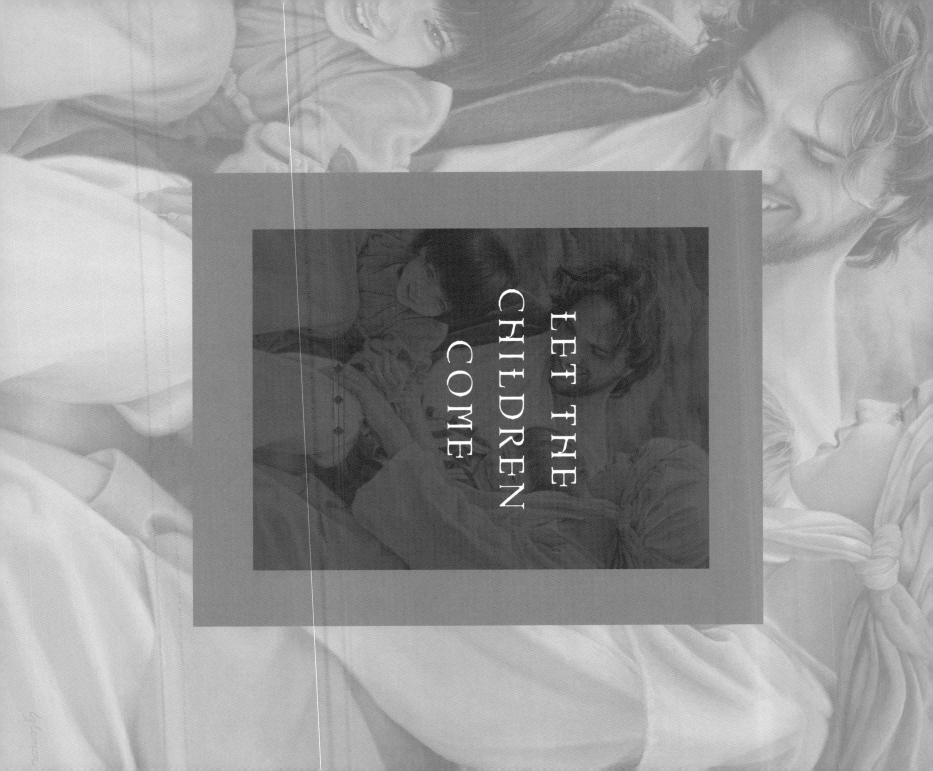

LET THE CHILDREN COME

Along with Mary and Joseph, Jesus returned to the obscurity of his childhood moorings, where the routine of daily life contrasted with conversations with learned doctors of Judah and Passover festivities. Although scholars have searched for clues as to the routine of Jesus' life in rural Nazareth, their purported "glimpses" into his youth hold little credence and speak more of the apocryphal than of the known. ¶ With scant factual information available, we turn again to Jewish tradition for insight. Although no details about this time are known from the Bible, it is safe to assume that Joseph the carpenter taught Jesus his trade. This inference is based on the Jewish tradition, "It is incumbent on the father to circumcise his son, to teach him the Law, and to teach him some

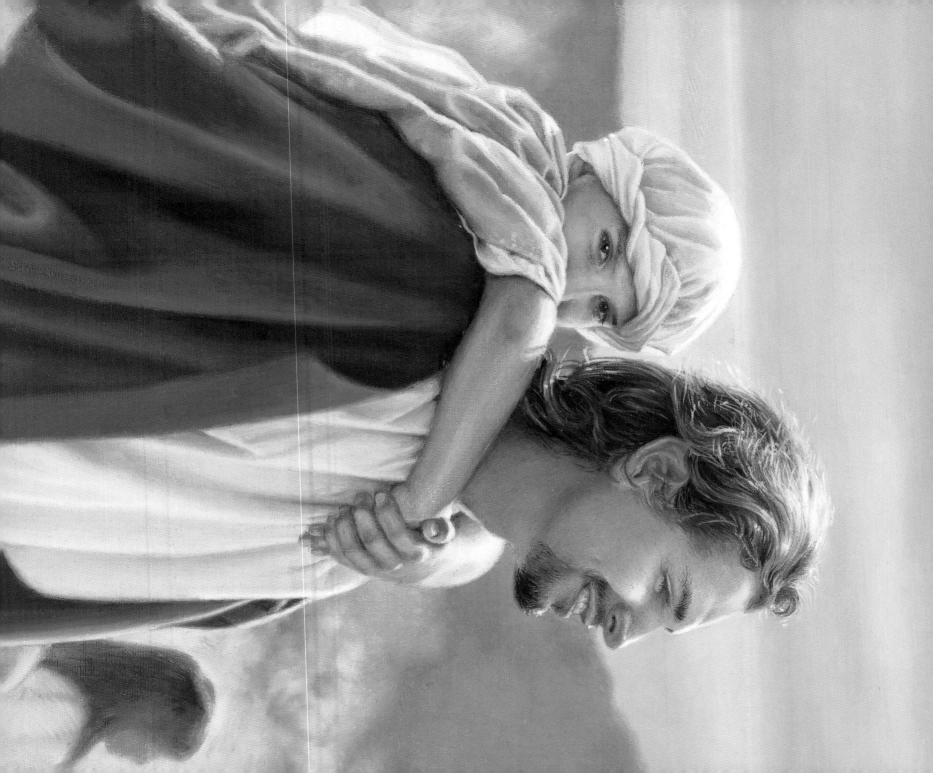

occupation." Since Joseph had complied with the first two requisites of the tradition and had returned to Nazareth with Jesus, now a Son of the Law, the third requisite of "teaching him some occupation" appears to be the likely next step. It is a step that the rabbis encouraged by pointedly teaching Judaean fathers that "He who does not teach his son a trade brings him up to be a robber."

Perhaps if Judaea had been independent of foreign rule, teaching a trade would have lacked such importance in the training of Jewish sons. In another time, the emphasis on learning a trade may even have been interpreted as parental preoccupation with material things. With the iron clasp of Rome over the heartbeat of the Judaean and Galilean regions for nearly eighty years, Jewish sons were not only encouraged to be tradesmen but were praised for their acquisition of important skills. Any attempt by Judaean youth to be more than tradesmen—politicians, soldiers, public tax collectors—cast them and their extended families into disgrace for its association with the ruling Romans. Weeping and lamentation for sons who had brought this type of disgrace upon the family was almost uncontrollable in small villages throughout Judaea.

Thus, becoming a tradesman was valued highly by fellow Judaeans during foreign occupation. Jewish families much preferred to see their youthful Judaeans in the marketplace wearing a small token depicting their trade so that passersby with the same heritage would nod with proud recognition. Teenage dyers wore brightly colored cloth, young tailors placed large bone needles in their cloaks, and apprenticed public writers wore wooden rulers behind their ears. These traditional symbols of Jewish tradesmen, although mocked by Rome, were as much expected of the new Sons of the Law as it had been of their fathers.

The generational link between father and son in family enterprises was the norm in Nazareth and other villages near Galilee in the days of Roman oppression. During centuries of servitude under the Romans, it can be assumed that Joseph's carpentry shop had been occupied by his father, and his father before him, and so on. Each generation had worked their skill and sold their artifacts to the highest bidder in the marketplace.

Scholars scoff at artists' depictions of Jesus laboring beside Joseph in a woodworking shop. They do not question that Joseph taught Jesus a trade, but they do question whether or not Jesus was taught to work in wood. If Jesus learned to work with wood, scholars ask, "Why is there only one reference to wood—a beam in an eye—found in the later teachings of the Master?" Adding to the riddle is the fact that wood carpentry

was an insignificant trade during the Roman rule of Judaea. In fact, the only era in which wood carpentry flourished as a public trade in Judaean history was during years of Jewish prosperity. Although Roman appointees in Judaea flaunted their prosperity at the time of Jesus, Judaeans living near the Sea of Galilee had little prosperity to flaunt. Therefore, many scholars now assume that Joseph taught Jesus the skill of working with stone, or stone masonry.

To successfully learn to work with limestone from Judaea or black basalt from the Galilee region was to enter a proud Jewish profession. Stonecutters, masons, and sculptors were highly valued in the Judaean society, and learning this type of trade would have brought Jesus high praise. Despite the number of references to stones and rocks in Jesus' metaphors, we still don't know for sure whether he worked with wood or stone.

We also don't know whether Joseph taught him his trade. There is no mention in the Bible of Joseph the carpenter during the teenage years of Jesus. Joseph, always depicted in the role of a protector, appeared in New Testament passages up until Jesus returned from the Passover festivities in Jerusalem. After his return, Joseph is never mentioned again. Although Joseph had protected the child Jesus from the atrocities of Herod and had been among the pilgrims journeying with Jesus

to Jerusalem, his further whereabouts are unknown.

Our only clue that Joseph was alive and residing in Nazareth is the scriptural phrase "[Jesus] was subject unto them." The word "them" suggests that both Joseph and Mary were with Jesus in Nazareth following the Passover festivities. Did Joseph train Jesus in the family trade of carpentry? Were there further instances in the life of the youthful Jesus to warrant the protective hand of Joseph? Did Joseph live to witness the Son of God maturing to manhood? The mysteries associated with Joseph the carpenter are far from solved.

There is no mystery about Jesus growing in "stature, and in favour with God and man" during his remaining years in Nazareth. And as he matured, grace by grace, the scriptures suggest that his thoughts turned heavenward. His profound question to his mother, Mary, at the Temple Mount, "wist ye not that I must be about my Father's business," revealed a focus on his true parentage—a parentage that would prepare him for his divine destiny. These intervening years would be a preparation for an ability to heal the lame, the blind, and the leprous. It would be a summoning of godly strength that would require the ability to command the waves of the sea, feed a multitude with loaves and fishes, and beckon the dead from the grave. Joseph the carpenter was needed in

Nazareth, a village built on the foothills of

lower Galilee, is today known as En–Nazirah or

Flower of Galilee. Perhaps, in quiet moments, young

Jesus enjoyed the sweet fragrance

of poppies and the cool breezes

that blew through

the hilly village.

Jesus' childhood, but Jesus would need more than a surrogate earthly father to guide him with these great and powerful gifts.

That needed father was God the Eternal Father.

Little is known of the guidance and instruction Jesus received from on high at that time, but it is known that the divine help prepared him to leave his childhood home of Nazareth and enter the wilderness of Judaea in search of John the Baptist.

The Son of God was baptized by John in the River Jordan, and afterward he "went up straightway out of the water: and, lo, the heavens were opened unto him, and he saw the Spirit of God descending like a dove, and lighting upon him." Then a voice was heard from heaven: "This is my Beloved Son, in whom I am well pleased." The Eternal Father was not the only one pleased that day or in the succeeding days.

The invitation of Jesus, "Follow me, and I will make you fishers of men," was joyously embraced by fishermen in small villages that bordered the Sea of Galilee. "Straightway [Andrew and Simon] left their nets, and followed him." Likewise, James and John "immediately left [their] ship and their father, and followed him." Philip of Bethsaida exclaimed, "We have found him, of whom Moses in the law, and the prophets, did write, Jesus of Nazareth, the son of

Joseph." Although these laborers were not present at the baptism of Jesus and did not hear the voice of God from heaven, they heard the voice of Jesus and knew that they had "found the Messias."

As they expressed joy over their discovery, curious Galileans came to see for themselves Jesus the Christ. After listening to the teachings of Jesus, they, too, joined in a throng of believers that followed the Master. And "there went out a fame of him through all the region round about. And he taught in their synagogues, being glorified of all."

However, the unrestrained adulation was countered. It is surprising, if not disconcerting, that the negative voices were heard from friends, kindred, and near neighbors in Nazareth. The circumstances surrounding this strange twist in the praise of Jesus occurred on a Sabbath day, a day in which followers of Jehovah in the small village of Nazareth stopped their labors to remember and observe the Lord's goodness to the Israelites.

On this particular day, Jesus "went into the synagogue" just as he had done on previous Sabbaths in his youth. Inside the synagogue he sat in the Holy Area, an area set aside for those waiting for the worship services to begin. Within the Most Holy Area sat the rabbi and other local dignitaries on the chief seats.

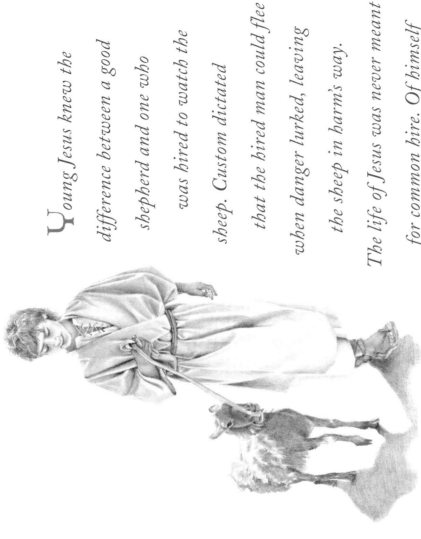

Young Jesus knew the difference between a good shepherd and one who was hired to watch the sheep. Custom dictated that the hired man could flee when danger lurked, leaving the sheep in harm's way. The life of Jesus was never meant for common hire. Of himself he proclaimed, "I am the good shepherd, and know my sheep." Though rabbinic law assured shepherds that they need not expose themselves to danger to protect their flocks, Jesus, as the good shepherd, would lay down his life for his sheep.

As the worship service commenced, prescribed prayers, scriptural recitations, and eulogies were spoken. After these preliminary rituals, the rabbi invited a few of those seated in the Holy Area to read scriptural passages. Although the invitation was at the discretion of the rabbi, when "some great rabbi, or famed preacher, or else a distinguished stranger, was known to be in the town," it was customary for the rabbi to designate him as one of the readers. Jesus was chosen to read that day.

He read passages from the scroll of Isaiah. "The Spirit of the Lord is upon me, because he hath anointed me to preach the gospel to the poor," he read. "He hath sent me to heal the broken hearted, to preach deliverance to the captives, and recovering of sight to the blind, to set at liberty them that are bruised, To preach the acceptable year of the Lord." When Jesus finished, "the eyes of all them that were in the synagogue were fastened on him." He then said, "This day is this scripture fulfilled in your ears," meaning that he was the promised Messiah.

"Is not this Joseph's son?" the congregated Nazarenes asked one of another. Seeing their failure to acknowledge him as the Son of God, Jesus exclaimed, "No prophet is accepted in his own country." Angered by his words, those seated in the Holy Area "rose up, and thrust him out of the city, and led him

unto the brow of the hill whereon their city was built, that they might cast him down headlong," meaning kill him. Fortunately, their murderous plans were prevented when Jesus "passing through the midst of them went his way." From that day forward, it was said of the Messiah, "Foxes have holes, and birds of the air have nests; but the Son of Man hath not where to lay his head."

Jesus would bid farewell to his childhood home of Nazareth and enter the wilderness of Judaea in search of John the Baptist, the promised child of Zacharias and Elisabeth. His request of John for baptism was met with a refusal. "I have need to be baptized of thee," John said. Jesus answered, "Suffer it to be so now: for thus it becometh us to fulfil all righteousness." Symbolically, the baptism of Jesus by his kinsman John represents the depth of his humility and his willingness to fulfill the law of God.

After his baptism by John in the River Jordan and his forty-day fast in the wilderness of Judaea, the mortal ministry of Jesus the Christ would commence along the Sea of Galilee. His ministry would attract multitudes from the Galilean region, yet repel many who once were his friends, kindred, and near neighbors.

Jesus' wandering status did not stop multitudes from hearing his words and following him from village

to village along the Sea of Galilee. They followed him from the wedding feast in Cana to Capernaum and the meadows of Bethsaida. They even followed him from the wilderness of Judaea to the Temple Courts in Jerusalem. They witnessed the probing questions of the Pharisees and scribes and the scoffing of the ungodly. Despite jeering from those who laid plans to entrap Jesus in his own words, multitudes followed him. And like a good shepherd, Jesus accepted all who came unto him, whether rich or poor.

The sick, the afflicted, and those who mourned, all seemed to know about his miraculous healing powers. Adult followers sought relief from personal infirmities and found relief in a miracle that dramatically changed their lives. They attributed their restored health to Jesus. There was another segment of followers that didn't know how to ask for help, but whose pain was real and whose suffering was exquisite. These were the children—the innocent ones. For them, the healing touch of Jesus was compassionately extended. For example, a certain man kneeled before Jesus and said, "Lord, have mercy on my son: for he is lunatick, and sore vexed.... And I brought him to thy disciples, and they could not cure him." Although healers of his day would have sent the man away, believing the son's

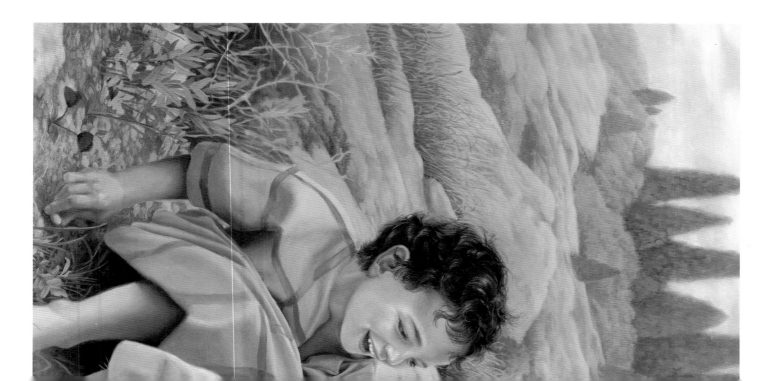

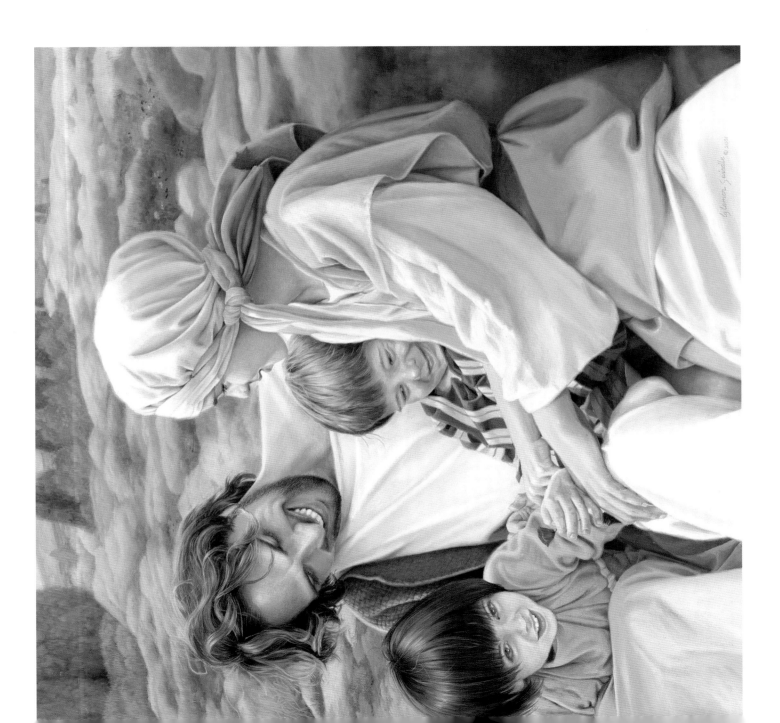

malady was the result of sin, Jesus did not. He "rebuked the devil," not the child, for the child was without sin. Immediately, the devil "departed out of him: and the child was cured from that very hour."

Likewise, Jesus did not turn away a Roman centurion, who was the commander of the infantry unit stationed at Capernaum. "Lord, my servant lieth at home sick of the palsy, grievously tormented," exclaimed the centurion. If he were truly asking for his servant to be healed, he was more enlightened than the Greco-Roman society in which he lived. A clearer translation reveals that the soldier was actually seeking mercy for his son, who was afflicted with palsy. Jesus, upon hearing of the suffering child, said, "Go thy way; and as thou hast believed, so be it done unto thee." It appears that he did not take into account the sins of the centurion or stop to weigh in balance whether the child of a foreign overlord should be cured. His love for the child had no national boundaries.

Even when the woman of Canaan, whom others viewed as an unclean gentile, cried, "Have mercy on me, O Lord, thou Son of David; my daughter is grievously vexed with a devil." Jesus informed the mother, "I am not sent but unto the lost sheep of the house of Israel." Then came she and worshipped him, saying, "Lord, help me." He did not refuse the mother's request. Her child, like the centurion's child and the certain man's child, was blessed with health.

Although an adult's grief turned from sorrow to joy at the witnessing of the miraculous, it was always the child who received the greater blessing. This is demonstrated again in the story of Jarius, a ruler of a synagogue, who "fell down at Jesus' feet, and besought him that he would come into his house: For he had one only daughter, about twelve years of age, and she lay a dying." When a servant attempted to divert Jesus from going to the home, saying, "Thy daughter is dead; trouble not the Master," Jesus could not be thwarted from his divine errand to help a child.

"Fear not: believe only, and she shall be made whole," he said to Jarius. "And when he came into the house, he suffered no man to go in, save Peter, and James, and John, and the father and the mother of the maiden. And all wept, and bewailed her: but he said, Weep not; she is not dead, but sleepeth."

Those who heard him claim that the daughter "sleepeth" laughed Jesus to scorn. They knew the child was dead and that any attempt to revive the maiden was futile. But they did not know of Jesus' love for the child. "He put them all out, and took her by the hand, and called, saying, Maid, arise. And her spirit came again, and she arose straightway." Her rising from

the dead was astonishing to her parents. Even those outside the house acknowledged that Jesus was more than a mere mortal.

Perhaps even more dramatic were the events that transpired when Jesus entered the city of Nain. In this small community, he witnessed a funeral procession passing from the town toward the burial site. Typically, women lead the procession, for Judaeans believed that a woman brought death into the world, and that each time death took a life, women led the dead to the prepared tomb.

Among the women leading the procession in Nain was the widowed mother of the deceased son. His body was carried on a bier behind the procession of women. In the Jewish tradition, those carrying the bier would rotate to give other family members or close friends an opportunity to perform a last act of kindness for the dead. Behind the bier were a minimum of two flute players and—where money was not an issue—hired mourners. As the funeral procession slowly advanced out of the community to the burial site, witnesses of the sorrowful scene were expected to join with the mourners. Therefore, it is assumed that

Jesus and his disciples joined the procession. However, when Jesus saw the sorrow of the widowed mother for her only son, "he had compassion on her, and said unto her, Weep not." He then "touched the bier: and they that bore [the body] stood still." Jesus said to the deceased, "Young man, I say unto thee, Arise. And he that was dead sat up, and began to speak." After he did so, Jesus "delivered him to his mother."

Jesus admonished his disciples to "take heed that ye despise not one of these little ones," for they are not inferior in God's kingdom.

These stories of blessings and the miraculous healing of children, even those who were dead, are not only unusual but out of character for the Judaean society in which Jesus lived. The birth of a child was cause for celebration, but too often the mother's joy was quickly tempered. In Judaic culture, children held an inferior status to adults and were often treated badly. Knowing this prevailing custom, Jesus admonished his disciples to "take heed that ye despise not one of these little ones," for they are not inferior in God's kingdom. When his disciples asked, "Who is the greatest in the kingdom of heaven?" Jesus answered by using children as a metaphor, "Verily I say unto you, Except ye be converted, and become as little children, ye shall not enter into the kingdom of heaven."

Jesus spoke here of the true nature of children and the kingdom of heaven, and he advised his followers to see beyond the cultural norm—to see each child as a child of God. He admonished them to love children and not be offensive towards them. At that time, an offense was defined as causing children to falter in faithfulness. Too often the offense came in the form of indecorous behavior or teaching of false doctrine. At other times, it was accusations hurled against children for being born with a mental or physical defect, which in Judaean society was an outward manifestation of sin.

Such untoward offenses hurt the tender feelings of children and led the innocent from a path of righteousness to bitterness for the unfortunate lives that they had to bear. The penalty Jesus suggested for such offenses was to place a millstone about the neck of the offenders and toss them into the sea. This penalty was not innovative nor a Jewish practice, but a hated Roman punishment for crimes of peculiar enormity in Judaea. For example, when Judas of Galilee led an insurrection against the Roman soldiers stationed at Galilee, the insurrectionists had millstones placed about their necks before being tossed into the sea. This form of death and improper burial was repugnant to Judaeans and greatly feared. But, for Jesus, the penalty was appropriate for those who harmed children in any way.

Jesus' teachings about the worth of children were not lost on his disciples. They listened and acted accordingly. Jesus, as the Resurrected Christ, acknowledged their obedience by referring to the disciples as "children." He did not say "men" or "brethren," for in the passage of time they had become like children. As they became more innocent, Jesus singled out Peter and gave a further admonition: "Feed my lambs." Although later he spoke of feeding his sheep, it was the young lambs that Jesus mentioned first. The innocent and the tender needed to know of his love and their importance in his Kingdom. Jesus had taught his disciples well. Children are a gift from God and each child the hope of ages past.

Yet of the many innocent children born upon the earth, there was only one child that was born of a virgin. This child was Jesus the Christ. He was the prophesied "Wonderful, Counsellor, The Mighty God, The Everlasting Father, The Prince of Peace." Although he was "despised and rejected of men," and became "a man of sorrows, and acquainted with grief," he triumphed over all enemies and conquered even death.

The story of this chosen child has been told through hundreds of generations, yet it never loses its greatness in the telling. To hear once again of the birth, the shepherds worshiping a babe, and the wise

men presenting rich treasures to a child, is to remember with joy the fulfillment of promises in ages past.

To follow the escape of the holy family from Bethlehem to Egypt is to know of God's care over his only begotten Son. And then to place Jesus in the rural setting of Nazareth growing toward maturity and in favor with God and man is to know of his preparation years. To read of his conversing with learned men on the Temple Mount is to realize that in his youth he knew of the divine destiny that awaited him—a destiny filled with hope and sorrow.

To read of his early years is to hear once again the beginning of the greatest story ever told. It begins with the angel Gabriel's announcement of high praise to Mary and closes with the silence of his youth in Nazareth. It is the story of Jesus the Christ that rivets our attention, for he is the Anointed One, the Promised Messiah, the Son of Man. ◇ ◇ ◇

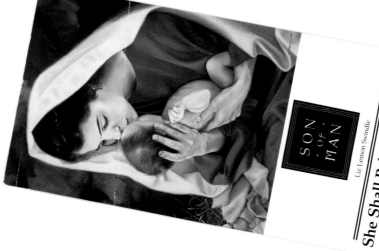

SON
· OF ·
MAN

Liz Lemon Swindle

She Shall Bring Forth a Son

I could probably paint a hundred paintings of Mary and her baby. The relationship of a mother and a child is not easily explained, even in a thousand words, but it comes immediately to our hearts with a picture.

This experience is universal and one of the greatest gifts of God. How great is God's plan that allows mere mortals to bring His children into the world, care for them, and help them make their way back to Him! How amazing that he trusts us when so much is at stake! How much more amazing then is the experience of Mary, the mother of Jesus? We worry about our own responsibilities as parents, yet she was the mother of the Son of God!

ReparteeGalleryGroup
1-800-366-2781 • In Salt Lake City, Orem, and Riverwoods

FOUNDATION ARTS